hello

WRITTEN BY HAND

Techniques & Tips to Make Your Everyday Handwriting More Beautiful

BY ERICA TIGHE

I LOVE *You*

happy birthday!

WRITTEN BY HAND

Techniques & Tips to Make Your Everyday Handwriting More Beautiful

BY ERICA TIGHE

ROCK
POINT

IMPORTANT

Brimming with creative inspiration, how-to projects, and useful information to enrich your everyday life, Quarto Knows is a favorite destination for those pursuing their interests and passions. Visit our site and dig deeper with our books into your area of interest: Quarto Creates, Quarto Cooks, Quarto Homes, Quarto Lives, Quarto Drives, Quarto Explores, Quarto Gifts, or Quarto Kids.

First published in 2017 by Rock Point, an imprint of The Quarto Group, 142 West 36th Street, 4th Floor, New York, NY 10018, USA
T (212) 779-4972 F (212) 779-6058 www.QuartoKnows.com

Rock Point titles are also available at discount for retail, whole sale, promotional, and bulk purchase. For details, contact the Special Sales Manager by email at specialsales@quarto.com or by mail at The Quarto Group, Attn: Special Sales Manager, 401 Second Avenue North, Suite 310, Minneapolis, MN 55401, USA.

10 9 8 7 6 5 4 3

ISBN:978-1-63106-386-2

Editorial Director: Rage Kindelsperger
Creative Director and Cover Designer: Merideth Harte
Interior Design: Tara Long
Managing Editor: Erin Canning
Editorial Project Manager: Chris Krovatin
Calligraphy and Illustration: Erica Tighe

Printed in China

MIX
Paper from responsible sources
FSC® C017606

I LOVE You

CONTENTS

hello

INTRODUCTION

Welcome!

In 2011, I was living in the middle of a forest, in Brazil, a few miles outside of a slum.

There were thirty-five of us in the community together—some children whose parents could no longer care for them, some disabled adults who needed daily assistance, and some foreigners who had come to take care of them. We had one computer for all of us, so we each had an allotted hour of the week that we could go on to email our families back in our home countries or even call them on Skype. The connection was always dicey, and oftentimes the rain would cancel the connection altogether. There were a few cell phones, but those were only used for local calls to arrange meet-ups with friends outside of our village; otherwise, you just walked to your neighbor's house if you needed something.

Life was slow. And the best communication tool that I had to reach my friends outside of Brazil was letters. I wrote so many letters. I wrote to everyone I knew, trying for some kind of connection to the outside world and detailing a life that was almost unimaginable in a first world country like my own. But I also wrote in hopes of receiving a letter back. So when the mail would arrive and someone would deliver a letter to me, I would take it in my hands and instantly know who had written it. I knew each person's handwriting—my dad's scratchy lettering, my mom's loopy script, my best friend's seal of a heart on the back flap.

That paper had been in their hands, their writing carried their voice and I knew that it took effort for them to write to me by hand. They couldn't just tap off a few sentences on the keyboard and send it to me. I would tuck the letter into my bed and wait until I was alone at night to read it. Seeing my loved ones' handwriting, something so uniquely theirs, made me feel close to them.

Often the subject they were replying to from what I had written them months before (one month for my letter to arrive to them and one month for their letter to arrive to me) would have been such old news that I had almost forgotten about it. I saved all the letters and cards that I received in my year and a half there. I pull them out sometimes and they take me back to a time

where my life was so simple—washing clothes by hand, cooking rice and beans in a huge pot, sitting for hours in prayer.

"I find that we are all searching for something human and authentic over something made by another machine."

Today life is not so simple in the big city of Los Angeles. My writing can all too often look like chicken scratch as I am trying to jot something quickly before running out the door. I have so many devices—iPhone, iPad, MacBook, iMac—it's a wonder that I would need to ever write with a pen. I can type out an email to my friend in Europe that will get to her in one second rather than ten days. I can keep my calendar on my phone that will sync with all my other devices instead of lugging around a planner. I can write notes that will stay in one place rather than get lost in my office. I can send an invitation to my birthday party using a site that will also collect RSVPs and send out email reminders to my guests rather than dealing with the hassle of going to the post office.

But I often don't do those things because I so greatly value what is written by hand. I find that I want to look at my to-do list when I take three extra minutes to write it beautifully, that my friends feel special when I send them a paper invitation with their names beautifully drawn on the envelope, that making a handwritten place card for my dinner party makes my friends feel known, that I can remember things better when I physically write them with my hand rather than typing them on a keyboard.

I find that we are all searching for something human and authentic over something made by another machine. I have a list of ten projects that I want to do around my home to make it more beautiful. They all require getting supplies at the hardware store and having enough time to undertake them. But what I love about handwriting is that it's something I can do every day. It can be done with a pen or pencil at my desk, and instantly a sticky note is a piece of art.

Recently while on a trip to Mexico City, I noticed that many of the museums had handwritten letters behind glass. I saw Frida Kahlo's handwriting and that of

her lover, Diego Rivera. These pieces of paper have become artifacts, something to hold on to and in many ways they are masterpieces in their own right. That is something I do not want to lose and something I want my children to learn. Our handwriting can live on much longer than we can. Those notes by my late grandmother are some of my favorite possessions.

Not only is handwriting about nostalgia and tapping into our humanity, but it has also been proven that handwriting has many positive effects on our brain. Reported by the *New York Times*, a study at the University of Washington supported a few findings:

> In a study that followed children in grades two through five, Virginia Berninger, a psychologist at the University of Washington, demonstrated that printing, cursive writing, and typing on a keyboard are all associated with distinct and separate brain patterns— and each results in a distinct

end product. When the children composed text by hand, they not only consistently produced more words more quickly than they did on a keyboard, but [they also] expressed more ideas. And brain imaging in the oldest subjects suggested that the connection between writing and idea generation went even further. When these children were asked to come up with ideas for a composition, the ones with better handwriting exhibited greater neural activation in areas associated with working memory—and increased overall activation in the reading and writing networks.

There we find the importance of continuing to practice our handwriting, to use our written hand even when it seems easier to type. Our brains become more activated with better handwriting, and that's reason enough for me to spend time scrawling letters on paper.

WRITING AROUND
THE WORLD

While living in Brazil, I was put in charge of our village preschool. I was still learning how to speak Portuguese, but I could get by with the pre-schoolers, while they taught me so many new things every day. I figured it was easy enough to teach the alphabet, so that's what we focused on until I had a better grasp on the language. I was very excited about how they learned to write the alphabet with me and thought I had prepared them to go to kindergarten in the bigger city with some of the other kids the next year. After their first week enrolled in the new school, I discovered that Brazilian children learned to first write in *cursive*, not print.

In the beginning of the twentieth century, teachers decided that it would be easier for children to learn to read and write using the same letterforms. They began teaching print as we know it today. However, a few years later, they decided that print-script was not appropriate for adults, so they went back to the cursive of the nineteeth century. Now in American schools, children first learn print and then learn conventional cursive (and sadly now, many schools have taken cursive out of the curriculum).

HERE IS HOW PEOPLE IN DIFFERENT COUNTRIES AROUND THE WORLD WRITE THE SAME SENTENCE

AUSTRALIA

This is the language that I learned to write

SWEDEN

Detta är språket jag lärde mig skriva på

SPAIN

Así es como he aprendido a escribir

POLAND

To jest język, w którym nauczyłam się pisać.

BRAZIL

Esta é a língua que eu aprendi a escrever.

ARGENTINA

Yo aprendí a escribir en este idioma.

MALTA

Din hi il-lingwa li tghallimt nikteb

While I was in Cuba last summer, I was struck by how almost all of their signs are still done by hand.

I must have taken a hundred photographs of street signs, store signs, menus, and more.

My friend and I were doing a project and were talking to many Cubans during our visit. We met some young men who were sharing with us about their daily lives and showing us around. They must have thought we were crazy because we kept making them stop so we could photograph another word.

The practice trained my eye to notice these things in my own city so now I snap photographs

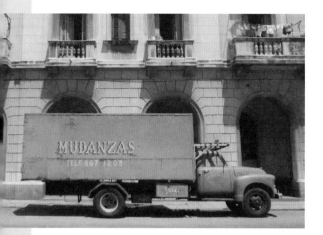

pages until it becomes second nature to you.

Keep an eye out for letters around your everyday life! There's hand-lettering everywhere, you just have to look for it. If you don't see any on your commute, keep your eyes out for the following:

>> Search #handlettering on Instagram and Pinterest

>> Look for old love letters in flea markets, yard sales, and museums (Googling 'old love letters' also yields great results)

>> Museum and library exhibits featuring letters and manuscripts by famous people

>> Check out other hand letterers like Joya Rose, Molly Jacques, and Chelsea Petaja

and keep a special album on my phone just for letters that I want to incorporate into my own everyday style.

You will begin to notice not only the letters themselves, but how they connect and play with each other. Maybe you don't love the way you write the letter 'M' (nor do you have to like how I write mine!) but you see the way it is written on the book on your coffee table and you study it to see how it is made. Then, attempt to copy it for a few practice

Soon, your eyes will be attuned to handwriting all over the world. But that doesn't mean you need to look for handwriting to imitate— half the fun of beautifying your handwriting is discovering your own unique style.

Ready? Let's get started!

FUN FACTS ABOUT HANDWRITING

» Graphology is the study of handwriting analysis.

» Small letters indicate that you are shy or withdrawn.

» Average letters indicate that you are well-adjusted.

» *Large letters indicate that you are outgoing and seek attention*

» Wide spacing indicates you enjoy your freedom.

» Narrow spacing means you can't stand to be alone.

» No slant means you tend to be logical and practical.

» Slant to the right means you are open to new experiences.

» Slant to the left means you tend to keep to yourself.

» Rounded letters mean you are creative and artistic.

» Pointed letters mean you are more aggressive and very intelligent.

» Connected letters mean you are logical and systematic.

» Heavy pressure indicates that you are good with commitment and have high levels of energy.

» Light pressure indicates you are sensitive and show empathy as well as lack energy.

» An open "o" means you are talkative and social with little secrecy.

» A closed "o" means you are very private and an introvert.

PRACTICE QUOTES

a great habit to get into is to write down quotes that make you think twice or inspire you. Even if you just scratch them into your notebook, write them down. Some of my favorite pieces are actually things I overheard someone say at the grocery store. Then, when you have a moment, you can reference your notebook to find quotes to write out beautifully.

When I was in grade school, my mom taught me how to measure out a paper to figure out how to center and align text when I was trying to make a sign to run for student council secretary. The skill has turned out to be one of the most useful things she ever taught me!

1 Measure your surface.

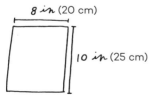

8 in (20 cm)

10 in (25 cm)

2 Look at what you're writing and decide what words/phrases you want to emphasize, if any.

what lies before us/ and what lies behind us/ are small matters/ compared to/ what lies within us./ And when you bring/ what is within/ out into the world,/ miracles happen.

HENRY DAVID THOREAU

Think about how you want to emphasize them.

>> Larger/smaller Lettering
>> Bolder/thinner lettering
>> Different style lettering
>> More spaced out lettering
>> Add a special drawing (check out page 148 for ideas!)

3 Count how many lines this will need on your surface.

1

2 *what lies before us*

3 *and what lies behind us*

4 *are small matters*

5 *compared to*

6 * *what lies within us*

7 *and when you*

8 * *bring what is within*

9 * *out into the world,*

10 * *miracles happen*

11 *henry david thoreau*

12

4 Divide the length of your surface by the number of lines (don't forget a space at the top and a space at the bottom!) to see how much space you can have for each line.

5 Use a ruler and mark the inches/centimeters down both sides of the surface.

6 Set the ruler to the marks on either side of the surface and draw a straight line across with a pencil. Do this down the whole length of the surface.

7 Find the center of your surface and mark it lightly at the top and bottom.

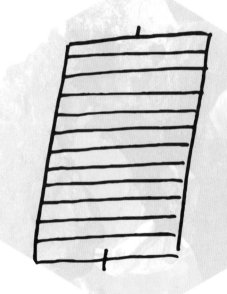

8 Now count the number of letters and spaces in each line and find the middle one—this will be the center of the line.

	NUMBER OF LETTERS/SPACES	MIDDLE
what lies before us	19	10
and what lies behind us	23	12
are small matters	17	9
compared to	11	6
what lies within us	19	11
and when you	12	b/w 6+7
bring what / is within	20	b/w 10+11
out into / the world,	18	b/w 9+10
miracles happen	15	8
henry david thoreau	19	10

9 Start from the center letter and write out the words for that line.

10 Then work backward from the center letter to the left of the surface.

11 Continue like this down the surface.

12 Once your ink has dried, use a clean eraser to remove the pencil lines.

If your surface is paper, you can use a light box to eliminate having to erase pencil marks on your final piece. Just draw on scratch paper, place it under your good paper, and trace over it with your marker, pen, or paintbrush.

I love to make greeting cards with my favorite quotes to mail to a friend or small inspirational prints to hang around my house or gift to someone.

WHAT LIES BEFORE US
AND WHAT LIES BEHIND US
ARE SMALL MATTERS
COMPARED TO
what lies within us
AND WHEN YOU
bring what is within
out into the world,
MIRACLES HAPPEN
henry david thoreau

SOME QUOTES FOR INSPIRATION:

He who seeks beauty will find it
—Bill Cunningham

A candle loses nothing by lighting another candle.
—James Keller

With freedom, books, flowers and the moon, who could not be happy?
—Oscar Wilde

To begin, begin.
—William Wordsworth

Now that you don't have to be perfect, you can be good.
—John Steinbeck

We are mosaics—pieces of light, love, history, stars—glued together with magic and music and words.
—Anita Krishan

The things you are passionate about are not random, they are your calling.
—Fabienne Fredrickson

The art of being happy lies in the power of extracting happiness from common things
—Henry Ward Beecher

I saw the angel in the marble and carved until I set him free.
—Michelangelo

LOOK AT YOUR OWN WRITING

We learn how to write our first letters around the age of four and continue to practice through about nine years old. And then that often remains our handwriting for the rest of our lives. We don't take the time to sit with it again as an adult and practice.

Before we begin, let's first see where you're at. Your handwriting is uniquely yours; it is how your mom knows you've mailed a letter before she opens it. In this book, we do not want to remove your personal hand, but instead improve it.

IMPORTANT

Write a few sentences in your everyday handwriting about a memory from your first years at school.

Let's analyze your handwriting. Is it:

☐ BIG

☐ small

☐ PRINTED

☐ script

☐ mix of PRINT + SCRIPT

☐ ALL CAPS

☐ Upright

☐ Slanted

☐ messy and hard to read

☐ clean and easy to read

☐ spaced out

☐ Close together

☐ EVENLY SPACED

☐ flourished

☐ Dark

☐ light

☐ loopy

This is not a test, but simply a way to see your own starting point. No matter whether you write straight up and down or slanted, big or small, there are a few key things that will improve your handwriting. If you write big, you don't need to force yourself to write small or vice versa, but you do need to:

>> **Evenly space.** Space your letters from one to the next.

>> **Stay consistent.** If you write small, then write small for all letters instead of randomly mixing in a large letter.

>> **Slow down.** We don't write often, but when we do, we tend to write very quickly, which is often the cause of messy writing. Write about three times more slowly than you think you should. This will help with your legibility.

Practice for a short period of time every day. Your hand will tire easily in the beginning until your regular practice strengthens your muscles beyond tapping on a screen or keyboard.

In the following pages, I offer many tips and give you various alphabets, but after practicing them with my handwriting, try to apply the lessons to your own handwriting. I have found most success because my writing is uniquely mine and is recognizable as my own.

GRASP

Something I didn't expect when I started teaching calligraphy classes was how many different ways there are to hold a writing utensil.

Generally everyday pens and pencils will allow the hand to be at any angle and still write. However, there are a few ways that are better than others to grasp a writing tool.

The first web space is between the thumb and index finger. If you make the letter "C" with your hand, this web space is described as "open."

A death grip on a pencil is when the webspace is closed.

Open

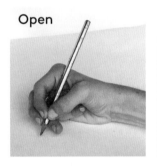

Closed

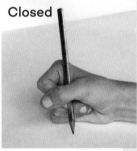

Here are the major parts of your hand:

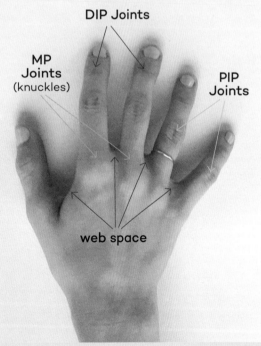

DIP Joints

MP Joints (knuckles)

PIP Joints

web space

See the difference?

When writing, the thumb, index and middle fingers are the movers and the pinky and ring fingers are the ones that hold the hand steady. The pinky finger should be set on the writing surface to stabilize the movements of the other fingers.

Do you tuck your thumb under your other fingers or set it on top?

While it is believed that a tripod grasp is the "correct" way to hold a writing tool, the quadrapod grasp is not particularly bad.

Tuck

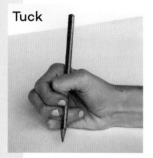

Wrap

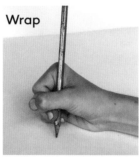

Tripod

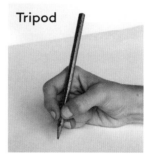

Quadpod

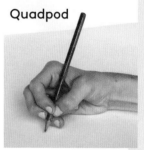

Do you write with your pencil in between your ring and middle finger? Or do you hold your pencil with just your finger tips?

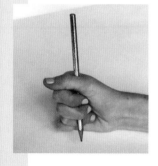

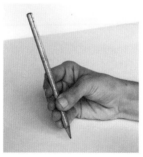

This gives the hand stability, but does not allow you to hold on too tightly. There is no reason to change the grip of your hand unless you find that your hand gets tired very quickly or easily. If this is the case, try to train your hand to hold your pencil with the tripod grasp—holding with the tip of your index finger, rested on the middle finger and held in place by the thumb. The other grips can cause strain on the wrong joints and muscles, which is what causes the pain.

TOOLS

This book is meant to help you improve your everyday handwriting—the kind you use to take notes at your work meeting, plan your week in your agenda, organize in your bullet journal, and make your to-do and grocery lists. The tools you'll need are very simple things that everyone most likely has lying around the house: a pen, a pencil, and an eraser.

Here are my favorites:

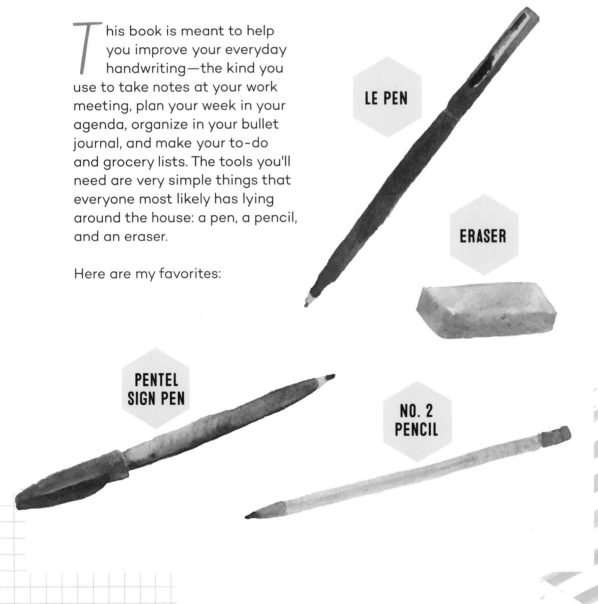

LE PEN

ERASER

PENTEL SIGN PEN

NO. 2 PENCIL

BASIC TERMINOLOGY & ANATOMY OF TYPE

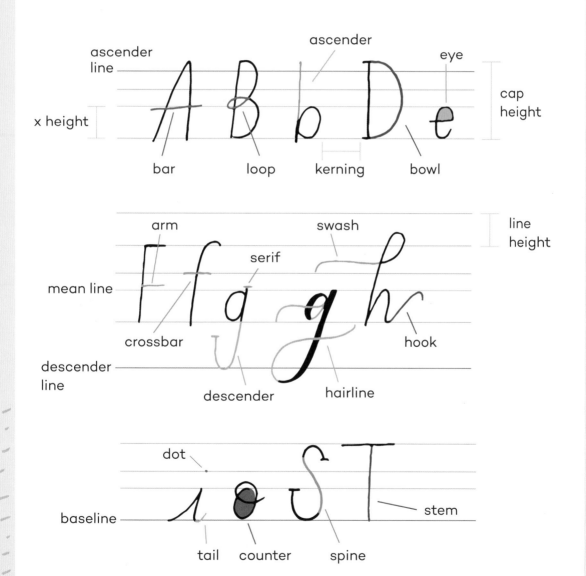

ascender line

ascender

eye

x height

cap height

bar

loop

kerning

bowl

arm

swash

line height

serif

mean line

crossbar

hook

descender line

descender

hairline

dot

stem

baseline

tail

counter

spine

Practice

PRACTICING THE DOWNSTROKE

Upstroke: any time that your pen is moving in an upward motion.

Downstroke: any time that your pen is moving in a downward motion.

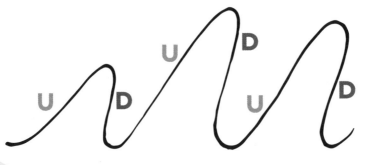

On the lines below, add a downstroke. The mistake I find most often is that the thick line is in the wrong place. The thick line is always a downstroke. It is mimicking a calligraphy pen that lets out more ink as the pen is moved downward.

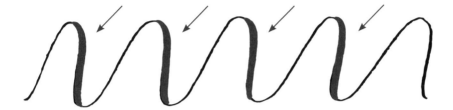

Now add the downstroke to these three examples.

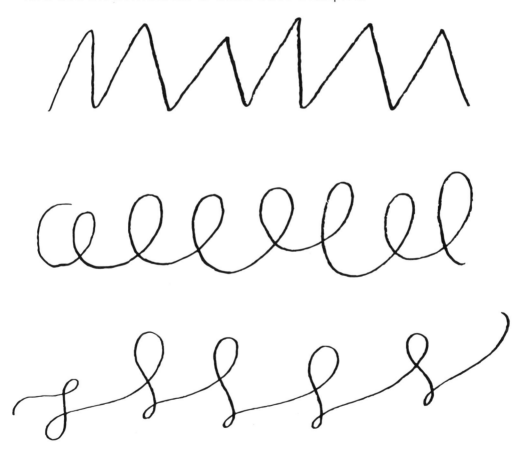

To warm up your hand, first practice tracing the lines below and then draw them on your own, making sure to add the downstroke.

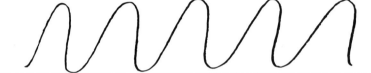

In your natural handwriting, write about what you wanted to be when you grew up and why.

Now, go back and fill in the "downstrokes" just as we did in the warm-up lines on page 29. Any time that your pen is moving downward, thicken the line.

Example:

fill in your downstrokes

Bolding parts of your letters is another way to differentiate your handwriting. You can do this with all types of lettering.

SPACING

almost as important to how you form your letters is how you space your letters. Letters too close together make it hard to decipher a word, and letters too far apart disjoint a word and can be difficult to read. It's important to remain consistent in the spacing so that there is an easy flow of words.

On top of that is the importance of line spacing and making sure that there is enough space between lines to make it easier to read. Hand lettering can lose its power if it just becomes a bunch of pretty markings instead of legible words.

Here, we'll take a look at spacing and how it affects hand lettering. Do the following exercises and take a moment to notice the difference that spacing makes.

Do you notice the difference spacing makes?

Not only is it important to have enough space between letters, but it is also important to have consistent spacing as you write. Consistent spacing will help emphasize or de-emphasize a word or sentence and also differentiate it from other words.

In the spacing provided below, write your favorite day of the week two times using capital letters and paying attention to spacing.

Write your favorite place two times using lowercase letters, once more paying attention to spacing.

Write the title of your favorite book in title casing (where the first letters of the words are capital letters) two times.

SIZING

Next, it is valuable to look at the importance of size. Each person will naturally write in a different size for their normal correspondence. The smaller the lettering, the more difficult for someone to read with ease, and lettering that is too large can look as though the statement is being yelled. Just like spacing, it is important to keep a consistent size in daily correspondence.

However, when wanting to differentiate content, sizing and spacing are very helpful. In general, if a word or phrase is written larger or more spaced out than the rest of the text, it will register to the reader as an important point. Rarely are conjunction words affected because they are the ones that make sentences flow and are not important points.

Use the following exercises to notice the difference that size makes in your own handwriting.

Practice writing some words in various styles: wider, thicker, taller, spaced out, close together. First practice the word as I have written it, then pick any word and write in the same style.

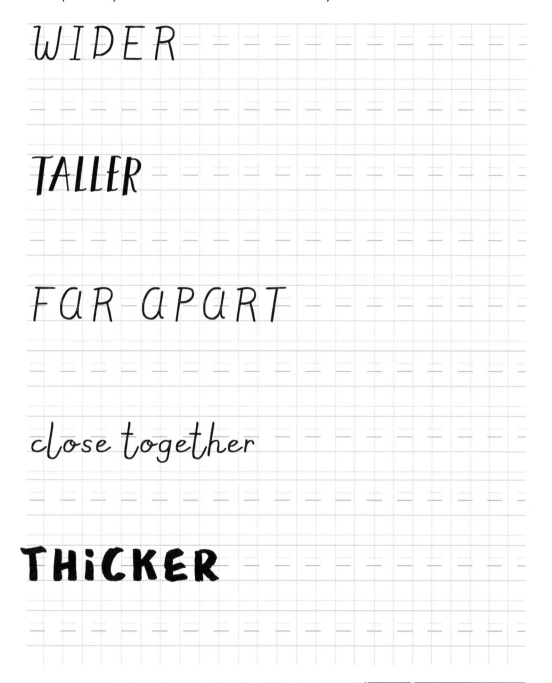

WIDER

TALLER

FaR aPaRT

close together

THiCKER

Do you notice the difference that size makes?

Although many of us have a "go-to" size that we tend to write, we can usually adjust our handwriting to fit a purpose. Size of lettering helps emphasize or de-emphasize a word or sentence and also differentiates it from other words.

Write about the best gift you've ever been given, filling up the space below.

Write a thank-you to the person who gave that gift to you.

Write the reason why you received the gift (a holiday, birthday, special occasion, just because).

TYPES OF
LINED PAPER

Various types of lined paper help you to practice specific lettering styles until they become second nature.

Lined paper helps with line height and getting proper ascenders, descenders, and bars. Practice your writing with the assistance of the lined areas below and opposite.

Ascenders, Descenders and Bars

Vertical lines are really helpful when you are working on your spacing and size consistency.

SPACING AND *sizing*

**PRACTICE
A FEW
WORDS**

Diagonal lines (at a 45-degree angle) can help you practice scripted lettering.

This is perfect for script

**PRACTICE
A FEW
WORDS**

BOLD SERIF

Bold serif fonts have a little line at the end of a stroke in each letter.

TYPES OF FONTS

Sans-serif fonts do not have the small lines at the end of each character.

Sans Serif

Script fonts are varied and fluid strokes, and are sometimes called cursive.

Script

Here, I provide some practice pages for you to see how letters in these three styles are formed. Also included is space for you to try your own hand at writing them. Don't let me have all the fun—it's time to add some lettering of your own to this book!

As you'll see, each lettering style has its own aesthetic features and boundaries. Sans serif might be easier for you than script, or vice versa. But learning different techniques is useful, so try to teach yourself how to best use each style.

Each style has its own unique features, so don't feel the need to rush through them or get them right on the first try (a novice boxer wouldn't fight a heavyweight champion at his first match!). Take your time, practice often, and don't get discouraged.

Practice the alphabet with these sans-serif letters, which are broken down to show the line strokes of how each letter is made.

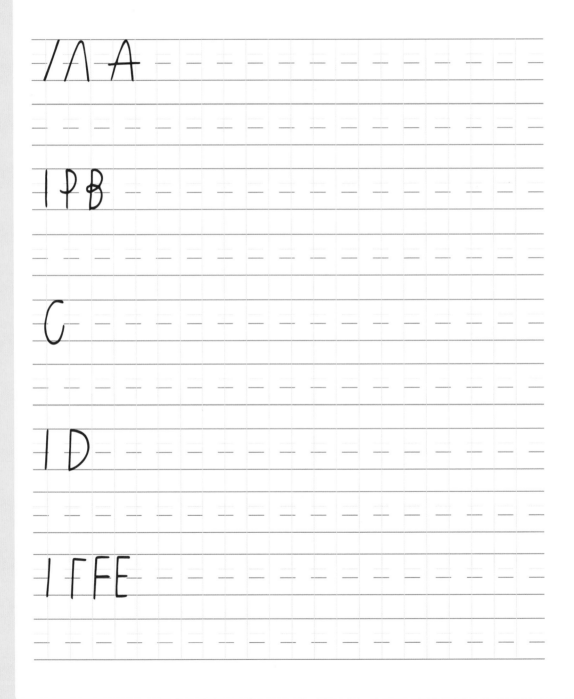

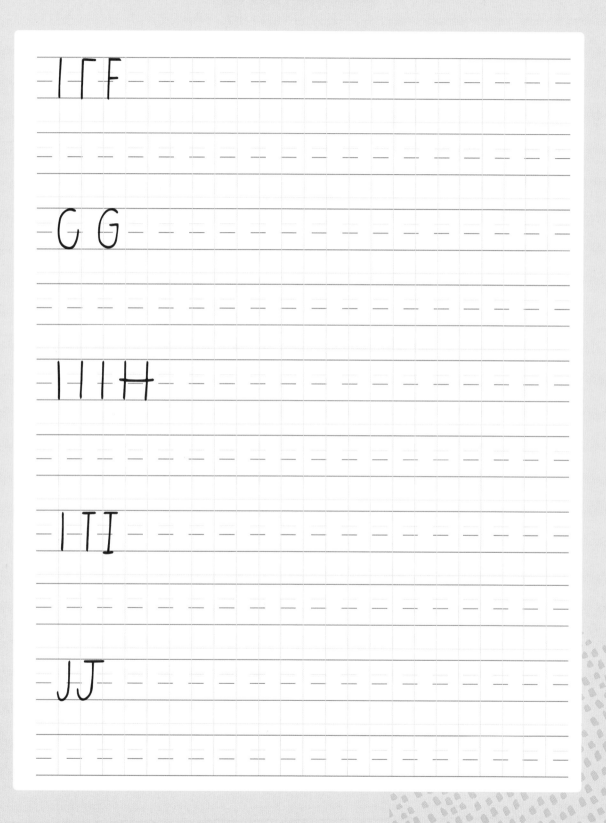

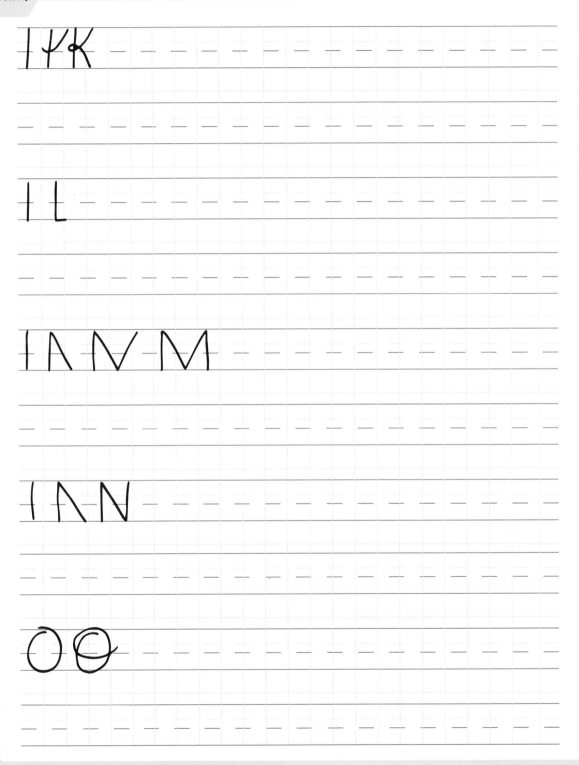

IYK

IL

IΛVM

IΛN

OO

IP

OQ

IPR

S

IT

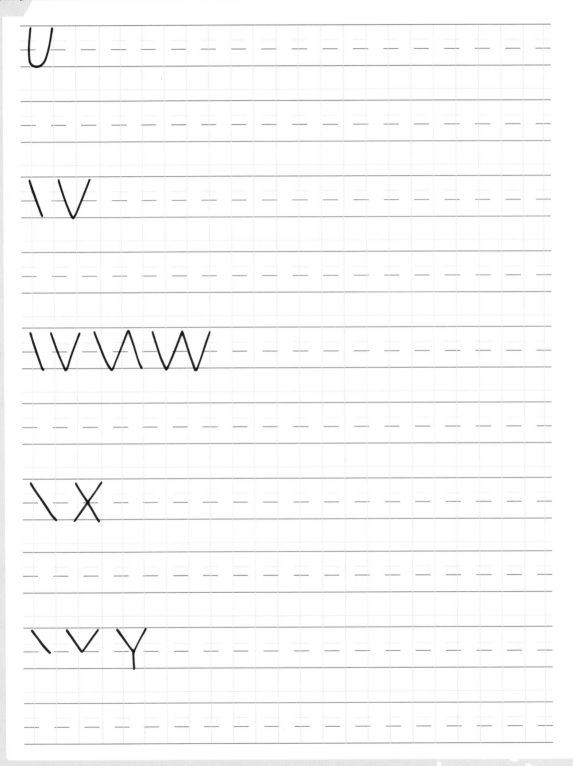

‾ 7 Z

LOWERCASE

o a

t b

c

o d

o e

ff

og

t h

t i

J j

l t k

l

l n m

l n

o o

l p

o q

i r

s

l t

v u

\ v

\ v\ w

\ x

ivy

¯ʒz

DAYS OF THE WEEK

MONDAY

TUESDAY

WEDNESDAY

THURSDAY

FRIDAY

SATURDAY

SUNDAY

**PRACTICE
A FEW
WORDS**

EVERYDAY WORDS

THANK YOU

TO DO

GROCERY LIST

NUMBERS

1

2

3

4

5

6

7

8

9

0

PRACTICE
A FEW
NUMBERS

SANS SERIF: STEP-BY-STEP

Practice the alphabet with these bold serif letters, which are broken down to show the line strokes of how each letter is made.

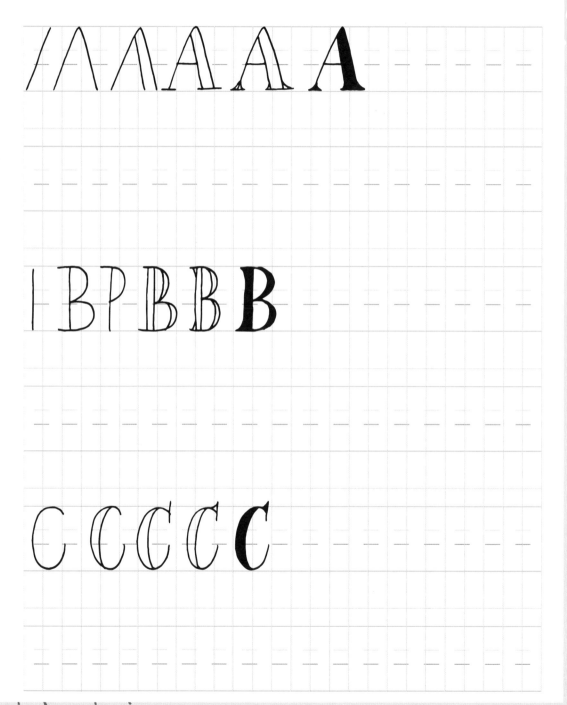



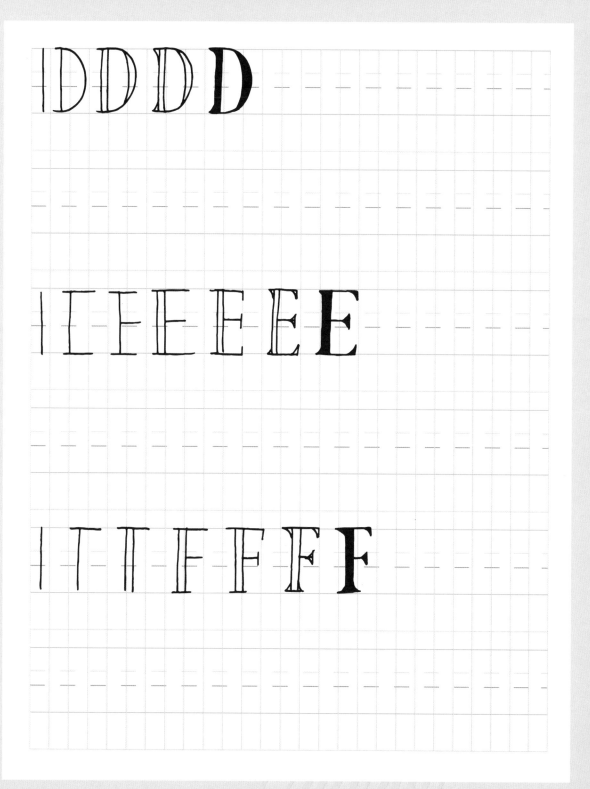

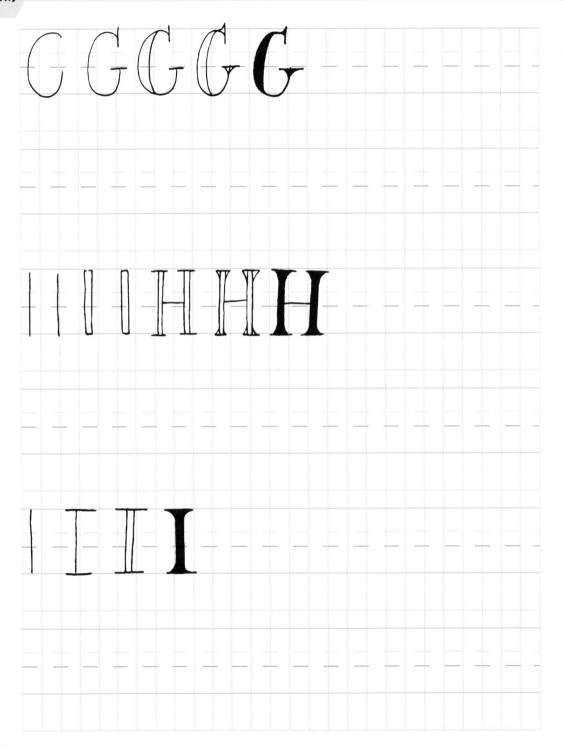

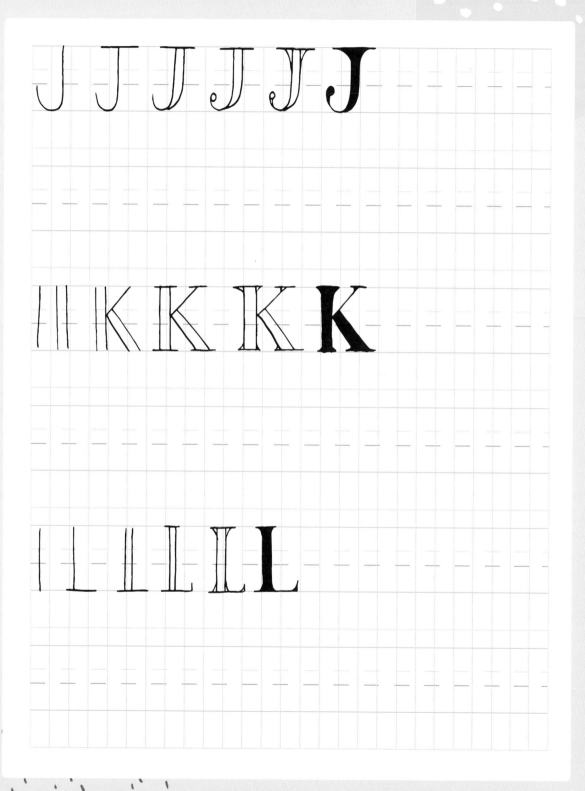

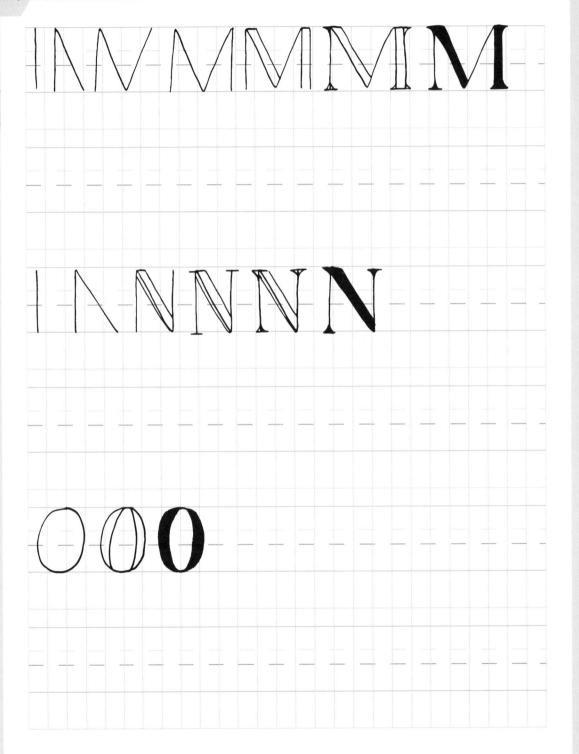

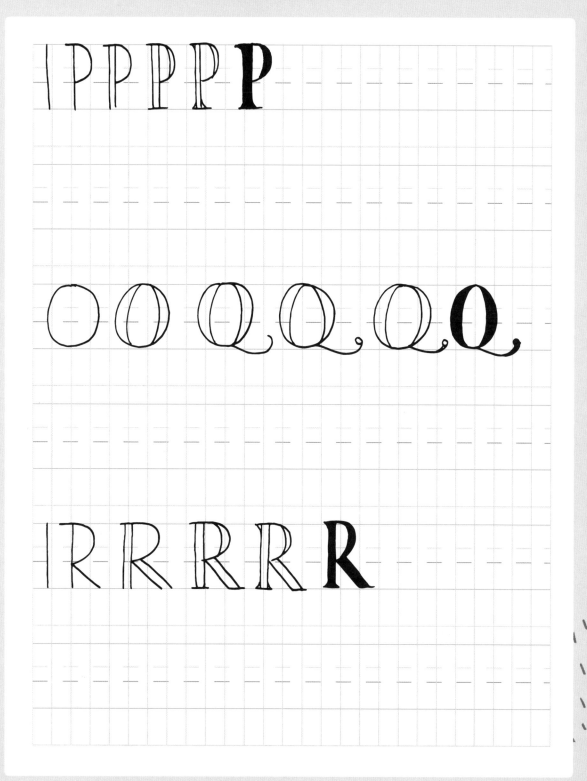

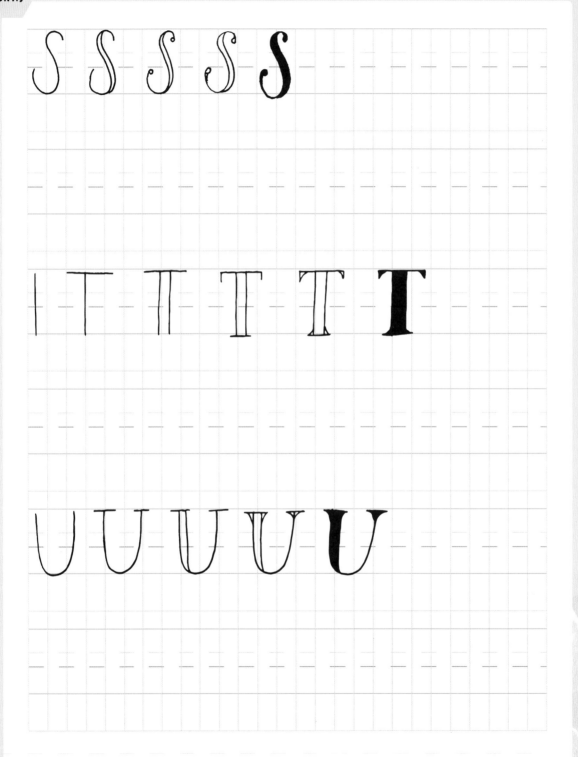

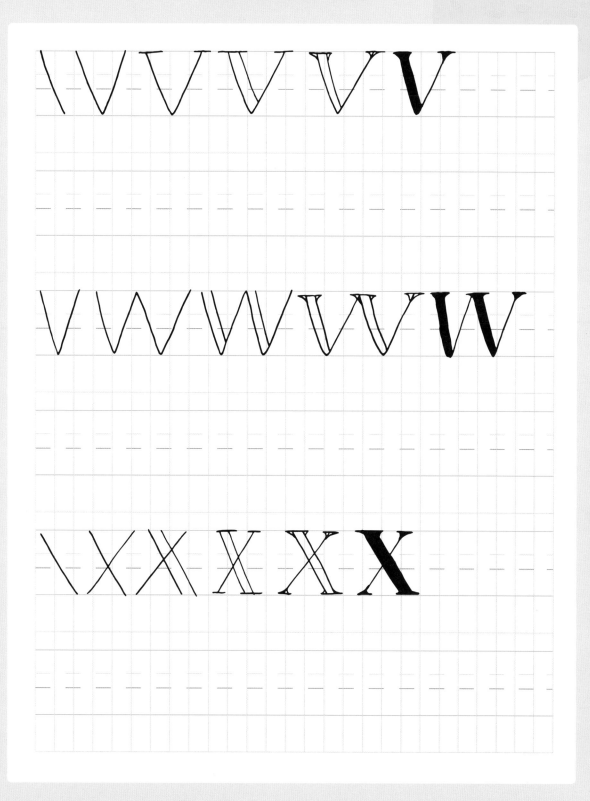

LOWERCASE

EVERYDAY WORDS

BYE

THANKYOU

MILK

PRACTIVE

MAKES

PERFECT

ENJOY

1 1 1 1 1 **1**

2 2 2 2 2 **2**

NUMBERS (CONT.)

PRACTICE
A FEW
NUMBERS

BOLD SERIF: STEP-BY-STEP

Practice the alphabet with these script letters, which are broken down to show the line strokes of how each letter is made.

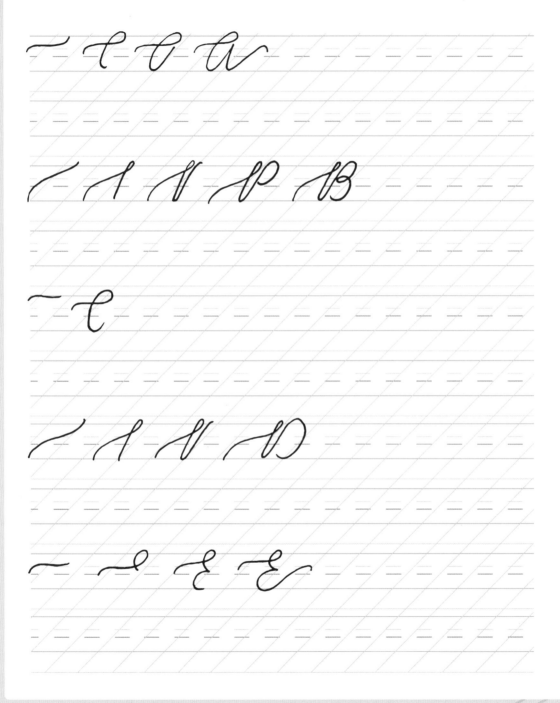

F F F

e g g

t t H

t t d d

t T J J

PRACTICE
A FEW
LETTERS

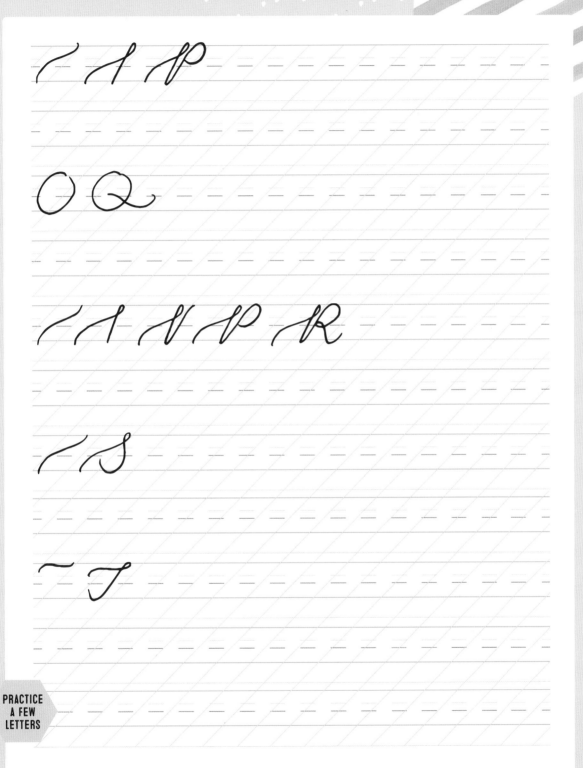

PRACTICE
A FEW
LETTERS

l U U

l V V

l V U U W W

ι X

ɾ ɾ ⌐ y y

PRACTICE
A FEW
LETTERS

LOWERCASE

**PRACTICE
A FEW
LETTERS**

~ J j

~ ~ l k k

~ ~ l l

~ ~ l n m m

~ ~ l n w

91

PRACTICE
A FEW
LETTERS

NUMBERS

1

2

3

4

5

6

7

8

NUMBERS
(CONT.)

9

0

PRACTICE
A FEW
NUMBERS

PRACTICE
A FEW
WORDS AND
PHRASES

SPACING & CONNECTING LETTERS IN SCRIPT

Spacing in scripted lettering is almost as important as the letterforms themselves. This is because, unlike other lettering forms, scripted letters connect to each other via their tails. With most letters, you can see the space between them and understand them as distinct markings; with scripted letterforms, the closeness can make them hard to read, even making single letters look like they've combined to form large, complicated new ones.

This is where the diagonal-lined pages really help. By writing your script at the same 45-degree angle as the lines, you can ensure even spacing.

Use these exercises to practice your scripted lettering. Try to make sure your lettering bends at the 45-degree angle.

ou

th

ea

ir

an

pl

ro

ay

at

ll

PRACTICE
A FEW
LETTERS

January

February

March

April

May

June

July

August

September

October

November

December

DAYS OF THE WEEK

Monday

Tuesday

PRACTICE A FEW WORDS

Wednesday

Thursday

Friday

Saturday

Sunday

EVERYDAY WORDS

Reminder

Don't Forget

Thank you

Please

PRACTICE A FEW WORDS

Dreams

FAUX
CALLIGRAPHY

hope

gratitude

according to the encyclopedia, calligraphy is the art of beautiful handwriting. It is generally done with dipped ink and various writing tools. I am, by trade, a calligrapher and find the art of learning calligraphy to be a wonderful skill to have. However, it is possible to create faux calligraphy with any basic pen.

On a calligraphy nib, there are two pieces of metal that separate. When the pen is making a downstroke, those two pieces open up to let out more ink, which is what creates the thicker line. The upstroke is then very thin.

An easy way to create a bolder font, without having to do block letters is to thicken your downstroke line.

To create this look, first write your normal scripted letters. Then, draw an extra line where the downstrokes are on each letter. Fill this in with your pen to create the faux look of calligraphy.

Be careful on curves. The thickness tapers off before you're all the way at the bottom. You can also thicken the curved lines in "B" and "D" and "P." "M" tricks a lot of people and they put the downstroke on the wrong lines. Remember to follow your hand to see where the actual downstrokes are.

Time to use everything you've learned! Remember spacing, sizing, and filling in the downstroke as you practice this faux calligraphy.

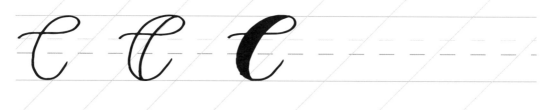

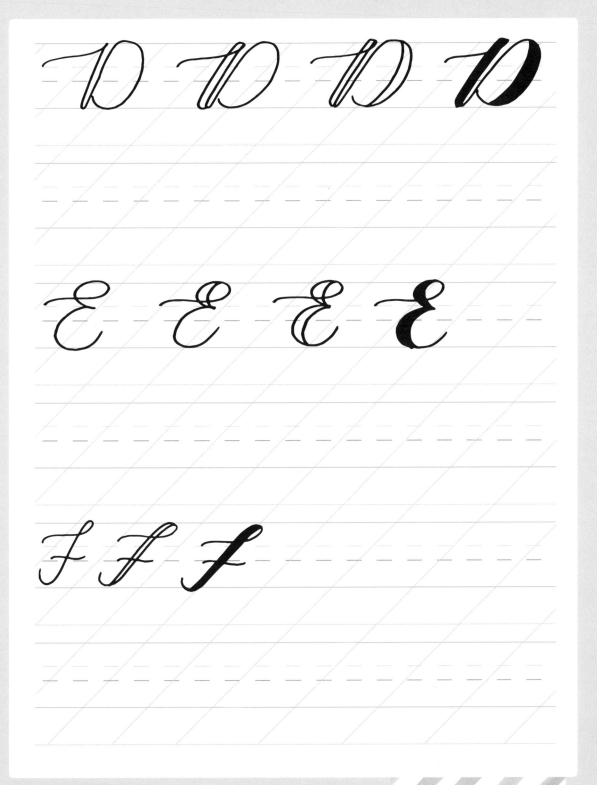

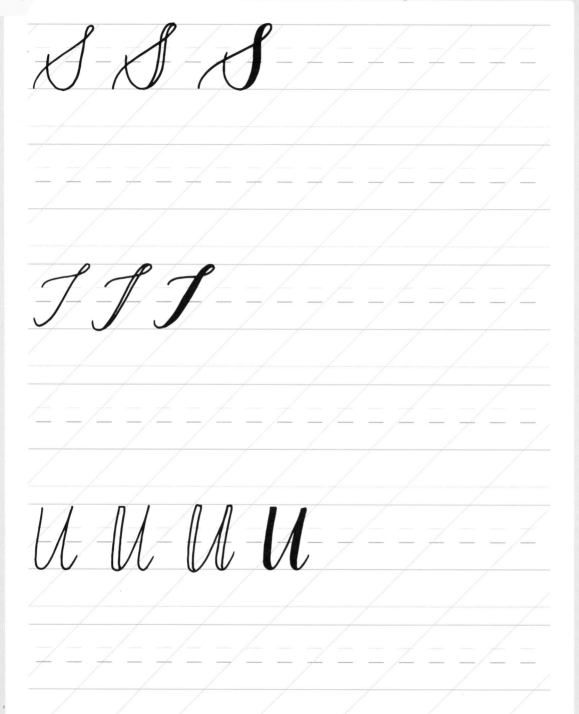

LOWERCASE

h h h h

i i i

j j j

n n n n n

o o o

p p p p

w w w w w

x x x

y y y y

3 3 3 3

NUMBERS

1 1 1

2 2 2

3 3 3 3

4 4 4 4

5 5 5 5

q q q q

0 0 0

PRACTICE
A FEW
NUMBERS

PRACTICE
A FEW
WORDS

groceries

GET PLAYFUL!

Once you feel comfortable with the lines and are being more consistent with your writing, get a little more playful. Practice changing the heights of the ascender and descender lines as well as the space in between letters.

thank you

Have fun with it! Now's your time to bend the rules of hand lettering and do your own thing. Be creative!

hey

hey

lol

lol

Rad

Rad

get real

get real

bae

~bae~

yolo

yolo

ALPHABETS

By now, you've seen so many upper- and lowercase versions of these fonts that you may have forgotten that they're part of the twenty-six-letter alphabet that you learned as a little kid. For quick reference, here are the alphabets of each of the fonts we've studied.

i

J

K

l

H

m N O

P Q r s

135

A B C D E

F G H I J

K L M N

O P Q R

S T U V

W X Y Z

a b c d e
f g h i j
k l m n o
p q r s t
u v w x
y z

A B C D E

F G H I J

K L M

N O P

Q R S T

U V W

X Y Z

a b c d e

f g h i j

k l m n o

p q r s t

u v w

x y z

A B C D E

F G H I J

K L M N N

O P Q R S

T U V W X

Y Z

a b c d e
f g h i j
k l m n
o p q r s
t u v w x
y z

A B C D E

F G H I J

K L M N

O P Q R S

T U V W X

Y Z

a b c d e
f g h i j
k l m n o
p q r s
t u v w x
y z

WRITING CORRESPONDENCE

At a flea market, I purchased a stack of love letters from the 1940s. My friend and I took the letters to a cafe and read them over tea and dessert. We traded off reading them in the order of the dates and tried to imagine the lives of this couple who was separated while the man was in the army. They truly were a piece of artwork.

It would be a really fun idea to find a friend with whom you could write pen-pal letters like we did as children. Or pretend you and your significant other are parted by distance and write letters asking questions and telling them things they might not know about you. Then, address the letters extra beautifully.

Sally Smith
124 FRONT STREET
LOS ANGELES, CA
9 2 0 0 0

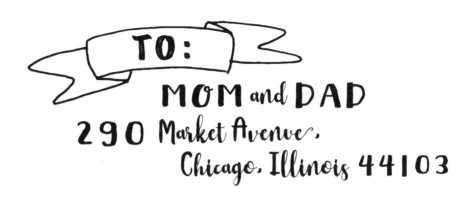

TO:

MOM and **DAD**
290 Market Avenue,
Chicago, Illinois **44103**

Here you can practice mixing and matching styles. I recently had a rubber stamp made of my return address, hand-lettered, because I write so many letters that I wanted to save myself a little time.

Other ways to make your mail extra special:

≫ Buy vintage stamps online (or in another country—I got mine in Cuba!) to adorn the front.

≫ Stock up on various colors of envelopes.

≫ Find a wax seal and wax and stamp all of your envelopes closed.

≫ Pull out your childhood sticker collection and use the stickers to decorate the letter and envelope.

ALEX APPLE
1584 South Street
Phoenix, Arizona
85776

HAPPY Birthday

MIXING
LETTERING
STYLES

i
LOVE
you

Things To **REMEMBER**

BE THERE *at 8PM*

One of my favorite things to do is mix different letter styles together. Most people tend to do this with their natural handwriting anyway, such as mixing scripted lettering with some print letters.

What follows is some mixed lettering styles to inspire your own practice. Have fun swapping out different lettering styles, and see what kind of atmosphere different combinations bring to your writing.

hope

JOY

BOOKS *to read*

5 years

Peace

fire WORKS

GRAPHIC TEXT

In many ways, hand lettering is a form of art on its own, but sometimes it's fun to add hand-drawn pictures to spice things up. Alone, flowery script letters just form words; on a banner, they become a header on a wedding invitation, or a tattoo waiting to happen! Try some of the graphic text styles I've included on the following pages.

you can FiLL IN A SHAPE

you are LOVED

STARBURST

starburst

FIREWORKS

fire
WORKS

SHADOW Choose a direction for a source of light. Then draw a line on the opposite side of each line like below.

Shadow

OUTLINE Write your letters with a pencil and trace around them with a pen. Then erase the pencil marks to leave an outlined lettering.

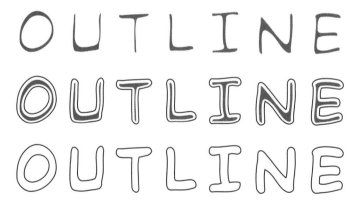

OUTLINE
OUTLINE
OUTLINE

BANNERS

1

2

3

4

you

are

LOVED

BANNERS

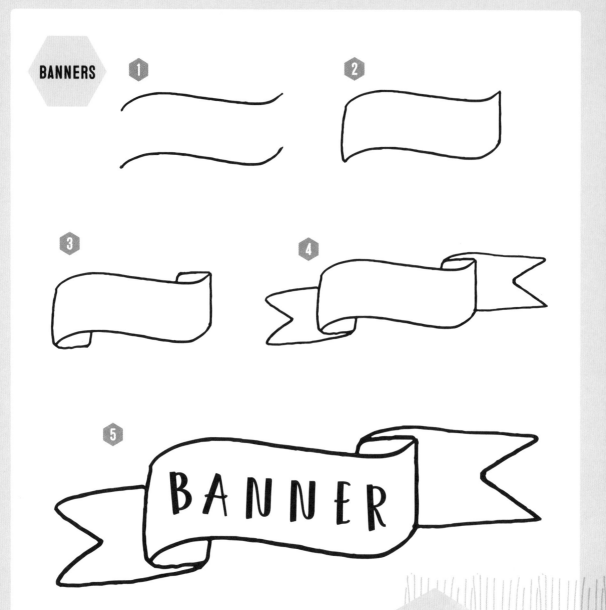

1

2

3

4

5

BANNER

FILL A SHAPE

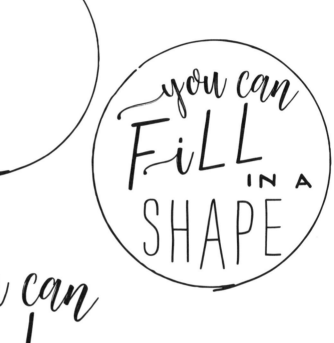

hope
JOY
Peace

notes

IN CLOSING

I encourage you to keep practicing and using your new skills every day. I'm sure you've already been noticing lettering all around you and wanting to use it in all that you do.

I recently asked someone who I met at a conference if he would write me a letter. He responded, "Okay, but if I do, don't judge my handwriting!" It made me laugh because I don't sit around thinking about other people's handwriting. However, it is a great opportunity to improve the activity we learned so long ago and quit perfecting at a young age.

If you feel like you've mastered the pen and pencil, don't be afraid to try modern calligraphy and brush lettering. It's so fun to letter with paints and ink.

I leave you with 50 prompts to get you writing. May they inpsire you to create beautiful hand lettering for years to come.

Share your work using #writtenbyhand so that we can all connect and support each other!

What are twenty things that you love about yourself?

Who or what inspires you the most?

50 WRITING PROMPTS

What has been the most surprising thing about growing older?

1 *Write out the recipe for your favorite home-cooked meal.*

2 What is your very first memory?

3 Pretend you are a tourist in your own city—what would you do if you only had twenty-four hours there? Make a list of bars, cafes, and restaurants you want to visit.

4 What memory comes to mind when you think of the word "happy"?

5 If money were no object, where would you go on your next vacation and what would you do?

6 Write about the hardest day of your life.

7 Write a letter to your twelve-year-old self.

8 Write a letter to your eighty-year-old self.

9 What is the greatest risk you've taken in your life?

10 Make a list of small ways you want to surprise people you love. Then add specific plans and dates to do those things

11 Make a list of things you love that are highly specific and idiosyncratic.

12 Write about your first kiss.

13 What outfit makes you feel most yourself?

14 What are twenty things that you love about yourself?

15 Think about a person who loves you unconditionally and write about what that feels like.

16 Write about a person who you love unconditionally.

17 What is your greatest fear in life?

18 What is your morning routine?

19 Nightly routine?

20 Write about a person you resent, and then write a letter offering forgiveness to that person or experience.

21 What is your greatest accomplishment? Was it personal? Professional?

22 What is something that scared you as a child?

23 If you could share one book with the world, what book would it be and why?

24 Come up with a mantra to use in times of stress. Write it ten times.

25 Write out your fantasy grocery list.

26 *What do you think about when you're surrounded by people?*

27 What do you think about when you're surrounded by people?

28 What has been the most surprising thing about growing older?

29 Write a letter that you would never actually send.

30 What is the best relationship advice you've ever been given? What about the worst?

31 Who was your favorite teacher in school and why?

32 When you think the world couldn't get any worse, what is one good thing that makes you think that good still exists?

33 Describe your dream partner when you were a teenager. What does your dream partner look like now?

34 What are ten things you are grateful for today?

35 What are you most passionate about?

36 What advice would you give yourself three years ago?

37 Are you putting any parts of your life on hold? If so, why?

38 What is the top priority in your life right now? What are you doing to focus on it?

39 What are your favorite parts about your job?

40 What are your least favorite parts about your job?

41 Who are the five people you spend most of your time with? Write each of their names in a way that reflects their personality.

42 Who has been the most influential person in your life?

43 What is your favorite place in the whole world?

44 Write the lyrics of your favorite song.

45 What was your favorite childhood book? Do you remember what it was about or why you loved it so much?

46 What is the nicest thing someone has done for you?

47 What is something that you have been putting off doing? Make an action plan to do it.

48 Make a list of all the places you've ever traveled. Write each place name in a different style.

49 What do you hope people will remember about you after you've died?

50 *Who or what inspires you the most?*

gratitude
DEDICATION & ACKNOWLEDGMENTS

I dedicate this book to my Grandma Sara whose dream it was to publish a book of her own, but never got the chance. She once told me that she imagined me as a card designer when I grew up and always taught me to dream big and travel the world.

I would also like to thank my brother, who always reminds me to keep putting myself out there, and my parents, who support me on all my big leaps of faith in this life.

And to all my friends near and far who have walked alongside of me on this journey to be a heart.

WORKS CITED

www.theanonymousot.com/2013/03/22/when-to-fix-a-pencil-grasp/

www.bfhhandwriting.com/history-of-cursive-handwriting

www.handwritingsuccess.com/about_us.php

www.zanerian.com/Palmer.html

dnealianhandwriting.blogspot.com/

www.quora.com/What-are-some-interesting-facts-about-graphology-handwriting-analysis